D1507727

Columbia University

Contributions to Education

Teachers College Series

No. 573

AMS PRESS
NEW YORK

EDUCATIONAL RETURNS
AT VARYING EXPENDITURE LEVELS

A BASIS FOR RELATING EXPENDITURES TO
OUTCOMES IN EDUCATION

By

ORRIN E. POWELL, Ph.D.

TEACHERS COLLEGE, COLUMBIA UNIVERSITY
CONTRIBUTIONS TO EDUCATION, No. 573

Published with the Approval of
Professor Mabel Carney, Sponsor

BUREAU OF PUBLICATIONS
Teachers College, Columbia University
NEW YORK CITY
1933

Library of Congress Cataloging in Publication Data

Powell, Orrin Edwin, 1889-
 Educational returns at varying expenditure levels.

 Reprint of the 1933 ed., issued in series: Teachers
College, Columbia University. Contributions to educa-
tion, no. 573.
 Originally presented as the author's thesis, Columbia.
 1. Education--United States--Costs--Case studies.
I. Title. II. Series: Columbia University. Teachers
College. Contributions to education, no. 573.
LB2829.P68 1972 338.4'3 75-177163
ISBN 0-404-55573-X

Reprinted by Special Arrangement with Teachers
College Press, New York, New York

From the edition of 1933, New York
First AMS edition published in 1972
Manufactured in the United States

AMS PRESS, INC.
NEW YORK, N. Y. 10003

ACKNOWLEDGMENTS

MAY I express my feeling of gratitude to all those students and members of the faculty of Teachers College, Columbia University, who have given time and thought to consider with me the many phases of this problem, and to the officials of the New York State Department of Education, through whose courtesy the needed data were always made readily available.

I am very much indebted to Professors William Heard Kilpatrick, E. L. Thorndike, Rudolph Pintner, Paul R. Mort, and especially so to Professors Mabel Carney, J. Ralph McGaughy, and William A. McCall for continued stimulation and guidance.

O. E. P.

CONTENTS

TABLES

EDUCATIONAL RETURNS
AT VARYING EXPENDITURE LEVELS

A BASIS FOR RELATING EXPENDITURES TO
OUTCOMES IN EDUCATION

CHAPTER I

THE PURPOSE AND SOCIAL SIGNIFICANCE OF THE INVESTIGATION

THE purpose of this investigation was to discover the relationship between current school expenditures and educational outcomes in one-teacher schools, and incidentally to arrange practical techniques for determining bona fide educational outcomes in any school community, and for relating these outcomes to expenditures.

Definition of Terms

The term "educational returns" is here used in a restricted sense. The educational returns on the expenditures in any community, in the operation of its school, are regarded here as the composite of all those educational changes which result from the educational activities and services purchased by that community with the money expended. The educational returns so defined include all those educational experiences of the school population and, indirectly, of the non-school population, in so far as they are influenced by the activities and services of the school.

Such a use of the term "returns" might not seem entirely appropriate; and yet this is the most acceptable term to use in the circumstances which actually prevail. The amount of money expended for education is the investment or principal, and becomes a sort of revolving fund with continuing returns from generation to generation.

Educational returns are purely measures of educational outcomes for school expenditures. They should not be confused with the total educational growth which takes place.

1

The term "current expenditures" is likewise used here in a restricted sense. It designates that part of the school district's total annual expenditures, exclusive of any expenditures for transportation of pupils, payment of tuition of pupils for attendance in other schools, or expenditures for capital outlay or debt service.

The main interest in this study was centered on the current, everyday running expenses of the schools. Accordingly, items of expenditure for capital outlay or debt service were in general excluded. Transportation and tuition expenditures were found not to occur generally and were therefore excluded in order to place the measured schools on a more comparable basis for study. Such items of expenditure were deducted from the total current expenditures of the school.

Does This Problem Have Social Significance?

Although the question herein considered has long been real, the increasing pressure of present social and economic conditions, which certainly affect education and are in turn affected by education, gives crucial immediacy to its solution. More and more, educators are realizing that in addition to its cultural phases there is a business side of education. It is not now a question of why measure returns, but why not?

Must not educational measures become more and more subtly sensitive to social and economic changes of human life in general, and of rural life in particular, for the best relating of any educational policy to relevant facts and forces? Is it otherwise possible for the taxpayer, the educator, the parent, the student, or society as a whole to keep best informed? How otherwise can intelligent utilization of funds or application of efforts for optimum educational planning be assured?

The measurement of returns in education was accepted as imperative in this investigation. Economically sound planning of fiscal programs for educational support had made such demands. Best educational thought had pronounced first-hand information in this field as essential.

Had educational expenditure variations actually been reflected in the resulting returns? Had there been certain desirable educational outcomes in general in those schools where expenditures were relatively high that were not to be found where expendi-

tures were lower? The lack of evidence on which to base de-
pendable answers to these questions, prompted this investigation.
Thus was taken the first step on which a longer series of problems
were hinging. It is hoped that in so far as education has remained
insufficiently planned, or to a too great extent uncontrolled, be-
cause of unsolved problems such as the problems here studied, the
possible applications of the findings may justify this investigation.

CHAPTER II

THE METHOD OF RESEARCH

AN experimental method of approaching this problem would be to set up two groups of schools with equivalent "outside of school" influencing factors, equivalent mental ability of the pupils, etc., but with unequal relative amounts of available funds for expenditures. The one group would be given sufficient funds for a definitely higher level of expenditure than would be available for the second group where funds would be limited to a definitely lower level. An initial test would be administered, measuring as completely as possible all the school children of both groups of schools. Each of the two groups would endeavor to make the most possible advancement with the funds at their disposal. At the close of the experiment a final test would be given, measuring the same pupils in the same subjects as were measured by the initial test at the beginning of the experiment.

The gains made by the groups in the interim between the initial test and the final test would then be compared. Any difference in gains between the groups might then logically be ascribed to the difference of expenditures.

Actually such a series of events has been taking place for some time as a part of the natural course of human events. While these different influencing factors had not been set up on a preplanned experimental basis, they were nevertheless just as truly operating. In this investigation it was but a matter of properly selecting those particular parts of the complex of events and forces which were most relevant to the adequate solution of the problem here set up.

The strictly experimental method of research on a preplanned basis not being practical or at all feasible, this study developed as an investigation that might bring into focus the same elements that would have been considered and evaluated if the investigation had been in accordance with the strictly experimental method.

4

What Type of Investigational Method Was Followed?

With the idea of using the equivalent groups method of investigation, schools were selected for comparison. This research in a sense employs the equivalent groups method of experimentation worked out backwards.

What Was the Nature of the Situation in Which the Investigation Was Carried Out?

The investigation was limited to New York State, and to the one-teacher school districts within the state. In 1930–31, the over seven thousand one-teacher schools of the state showed a variation in the amounts of their current expenditures of from $600 to $3,800, the median expenditure being a little less than $1,500. The legal minimum teacher salary was $800. The cases under $800 comprised schools which were not maintained for the full school year of 38 weeks.

These figures and other data were obtained directly from the District Superintendents' Abstracts of Trustees' Reports for each of the many supervisory districts of the state. The sources were made available through the New York State Department of Education at Albany.

Certain sections of the state are more typical than others, more representative of the general rural school situation of the state as a whole. Certain counties were found more typical in range of expenditures made annually in the different one-teacher school districts.

One county was selected for intensive study of educational returns. The county chosen was thought to be fairly representative of the state and it was extensive enough for the drawing of fairly reliable conclusions from the findings of the investigation. It was typical of the whole state in range of expenditures in the one-teacher schools, and was sufficiently representative in other ways to be acceptable for this study. The one-teacher district expenditure amounts of the county varied from $1,000 to $3,219 and the median expenditure was $1,463.

The county, which is kept anonymous in this report, lies about two-thirds the way down the Hudson between the River and the New England States, far enough from New York City to be in no way suburban to it, and near enough to New England to be heir to defense of the free public school. Dotted throughout

the county with its wooded hills, its green valleys and streams, are some 90 rural schools, 90 one-teacher districts. Their local names, such as Chestnut Ridge and Shady Dell, are often indicative of their surroundings and their setting.

The residents of this county, the children in the schools, and the teachers and district superintendents and trustees in general gave willing and interested assistance to make this investigation possible, for which sincere appreciation is hereby acknowledged.

CHAPTER III

SELECTION OF SCHOOLS

In the selection of individual schools to make up the two groups for a comparison of returns, the amount of expenditure was the first point considered. An average annual expenditure of $1,500 was taken as the line of demarcation between the two groups of schools. Those schools with expenditures of more than $1,500 were placed in Group A, and those schools with expenditures of less than this amount were placed in Group B.

The distribution of schools was made on the basis of their average expenditures for the three school years 1929–30, 1930–31, and 1931–32. The expenditures of the measured schools, when checked back for three years, showed each school to have approximated very closely for the three-year period its relative position of 1930–31. In the average expenditures for the three years, all but 3 of the 70 schools fell on the same side of the median as they did in the distribution of 1930–31 expenditures. In the upper ranges, one school shifted from above $1,800 to below $1,800 and one from below to above this level. In the lower-expenditure levels, one school shifted from above $1,300 to below $1,300 and five schools shifted from below to above this level.

It was desired to trace the expenditures back for five years. Because of a change in the method of reporting such expenditures to the State Department of Education, the earlier figures would have been much more difficult to determine. The added cost and trouble did not seem warranted, as the three-year trend was thought to be an acceptable index of what the probable expenditures had been for the preceding two years.

How Much Did These Two Groups of Schools Differ in Expenditures?

The pupil-weighted average expenditure of the schools of Group A was $1,703 as against $1,354 in the schools of Group B. The difference in average annual expenditures amounted, therefore, to $349.

How Were the Measures Weighted in Computing the Averages?

Computation of the pupil-weighted average in any group measure is comparatively nontechnical. The following example will illustrate the procedure: The average expenditure in a particular school in Group B is $1,261. From this school, after all necessary discarding of individual cases, suppose there remain the scores of 7 different pupils. The total number of cases in Group B is 124. The average expenditure, $1,261, multiplied by 7 (the number of cases retained from that school) gives a product of $8,827. This product of $8,827 plus the products similarly calculated in each of the other individual schools of Group B gives a pupil-weighted total group expenditure. This total divided by 124 (the number of cases in Group B) gives the pupil-weighted average expenditure for the schools of Group B. This hypothetical school with 7 pupils' scores included in Group B's total of 124 cases would have 7/124 of the weighting of this whole group.

The total influence of the amount of expenditure upon achievement, for instance, is proportional to the number of pupils attending the school.

In order to make a significant study of the relationship between expenditures and returns in education it becomes necessary to have complete information concerning the amount of expenditures of each school included in the study. The expenditures of each school must be properly weighted in computing the total and average expenditure for the different groups of schools. Similar weightings are necessary for achievement scores, which constituted the chief measure of educational returns in this study. Throughout this report the significance of differences in achievement will be discussed with expenditures of each school weighted according to the number of pupils from that school whose scores are included in any group.

The enrollment in the different schools concerned in the investigation was so highly correlated with the numbers of scores from the different individual schools in the two Groups that the weighting on this basis was the most practical where any analysis of probable causal influencing variables was to be attempted. The Pearson r as a coefficient of correlation between Group A and Group B was positive .617, and was much higher for the total non-shifting school population with which lay the main concern in this study.

The desire to select the schools so as to have fairly similar community influences in each of the two groups was a guiding purpose in selection. The schools for both groups were chosen from a fairly compact and more or less closely interlinked area. In some cases, selected high- and low-expenditure schools were immediately adjacent to each other. This closeness of location, especially in open country, tends to level out many of the social differences through a varied and extensive interchange of experiences. The conditions were fairly uniform in the two groups of districts though it is to be expected that there were some environmental differences remaining after the attempted equating of the two groups, A and B.*

Did the High- and Low-Expenditure Schools Have the Same Supervision?

Another influence to be held equal in the two groups of schools was that of supervision. Four different Supervisory Districts were covered in this investigation. The influence of supervision was equated by measuring in each Supervisory District entered, equal numbers of schools with expenditures above and below $1,500, the approximate median expenditure for the whole group of such schools of the state and of the county where the measures were made.

To illustrate this method of equating the supervisory influence, let us suppose that in Supervisory District No. 1, there were found 15 schools, 6 of them with expenditures above $1,500 and the other 9 with expenditures of less than $1,500. Measurements were made in the 6 schools with expenditures above $1,500 and in only 6 of the 9 schools with expenditures below this amount. The number of schools of above-median expenditures and the number of schools of below-median expenditures were thus kept equal in Supervisory District No. 1. The supervision in the 12 selected schools was by the same person and therefore could be considered equivalent. This procedure was followed in each of the four Supervisory Districts where measurements were made.

The desire to include some schools at all the different levels of expenditure likewise influenced the selection of schools. A school

*Equating the different groups on intelligence as measured by the McCall *Multi-mental Scale* probably tended to eliminate a large portion of the effect of whatever community differences there may have been.

or two with expenditures of about $2,600 or $2,700 would have been included in Group A if other low-expenditure schools could have been found in the same Supervisory District to balance these schools in Group B.

By this plan data were assembled from 70 different schools. The supervision in the 35 schools of Group A with expenditures of more than $1,500 was by the same persons as was the supervision in the 35 schools of Group B where the expenditures were less than $1,500.

CHAPTER IV

WHAT CHILDREN WERE MEASURED

THE first proposal for the abbreviation of the system of measurement was that not all children in any school need be measured in order to ascertain what educational returns are being secured in that particular school. Accordingly, only 10-, 11-, 12-, 13-, and 14-year-old children in each of the 70 schools were measured. Had enrollments been large enough, the measurement of 12-year-old children only would have done just as well; but in the scattered rural schools where the enrollments were small, some schools having but three or four children enrolled, this plan would not have been practical. It would not have given a sufficiently large number of cases without the measurement in hundreds of different schools. In some of the schools investigated not a single 12-year-old pupil happened to be in attendance at the time of this investigation.

There are various methods of selecting the children, where it is proposed not to measure all of them. The method of random sampling may be seriously objected to because of the degree of uncertainty of fair sampling, especially in small rural schools. The method of measuring children of certain grades meets with equally serious objections. Irregular promotions and differing standards of promotion make this plan undesirable for sampling. The plan described proved practical for the purposes of this investigation.

How Long Had the Pupil Attended the School in Which He Was Measured?

There were retained for the final comparison of the two groups of schools the measures of only those individual pupils who had attended no other school for the five years immediately preceding the investigation. In Group A the number of cases was 169, in Group B the number was 129.

This plan was followed in order to secure, for comparative pur-

11

poses, measures of educational changes of two groups of pupils, one group having been in schools of more than $1,500 expenditures and the other having been in schools of less than this amount of expenditures for a period of five years—a long enough time to determine the relationship between expenditures and returns in education.

Each school had tended to hold its same relative expenditure level from year to year; the children who had attended the same school for the period of five years had thus experienced the cumulative effect of whatever kind of training was given in such schools.

How Were the Measures Made?

Measurement of pupils was made by the use of the *Rapid Mental Survey Test* which was arranged especially for use in this particular investigation, and was made possible through the generous coöperation of the authors of the different tests sampled. The *Rapid Mental Survey Test* was made up by the grouping of a 20 per cent sampling of items from the McCall *Multi-mental Scale*, a 10 per cent sampling of items from all but one section of the *Modern School Achievement Tests* by Gates, Mort, Symonds, Spence, Craig, Stull, Hatch, Shaw, and Krieger, a 50 per cent sampling of the spelling test section of the Pintner *Educational Achievement Test*, and sixteen items from McCall's preliminary and as yet unpublished *Happiness Scale*.

The tests were administered at the school buildings by the investigator with the aid of trained and experienced associates. Each pupil was measured in his own school and under conditions most conducive to fair measurement. Uniform procedure was maintained and the administering of the tests and of all other measures made was completed during the last three weeks of May, 1932. All tests were scored with the aid of trained assistants and were checked by the author.

CHAPTER V

MENTAL ABILITY

Were the Higher-Expenditure School Pupils Superior in Mental Ability?

THE intelligence of each pupil in the two groups of selected schools was measured by the use of the McCall *Multi-mental* section of the *Rapid Mental Survey Test.* The items of this section of the test were arranged in the order of increasing difficulty; the scores represented the total number of answers correctly made.

Since only a 20 per cent sampling of the items of the McCall *Multi-mental Scale* was used in this test, the norms for the Scale and the regular technique for obtaining the intelligence quotient could not be employed. The crude score was taken as a measure of the degree of mental maturity, and an index of intelligence was devised by taking 100 times the crude score divided by the chronological age in years. The 20 per cent sampling of the McCall *Multi-mental Scale* was made by taking every fifth one of the hundred questions of the original Scale.

The measurement of mental ability of the two groups of pupils showed a small difference in favor of the higher-expenditure schools. It seemed obvious that should any difference in the relative learning of these two groups of pupils be discovered, it would not be accepted as necessarily due to the difference in expenditures if one group was brighter than the other. Therefore, a sufficient number of individual cases were discarded in order to make Groups A and B equivalent in average mental ability. This left 163 cases in Group A, the higher-expenditure schools, and 124 cases in Group B, the lower-expenditure schools.

The two groups had equal average crude intelligence scores, 10.54. The two groups were practically equal in average chronological age; Group A averaged 11 years 7 months and 17 days, and Group B averaged 11 years 7 months and 16 days plus. The average intelligence indices were equal to tenths place, 90.6. These facts are recorded in Table I.

13

TABLE I

THE TWO GROUPS OF PUPILS EQUATED ON INTELLIGENCE

GROUP	MEAN CRUDE SCORE	MEAN CHRONOLOGICAL AGE	MEAN INTELLIGENCE INDEX
A........	10.54	11 yrs. 7 mos. 17 days	90.6
B........	10.54	11 yrs. 7 mos. 16 days	90.6

The relative mental maturity of the pupils of the two groups is dependent upon the variation of individual scores as well as upon the average or mean scores. The frequency distributions of the individual crude intelligence scores of the groups are shown in Table II and the frequency distributions of the individual measures of chronological age of the two groups of pupils are shown in Table III.

TABLE II

CRUDE INTELLIGENCE SCORES IN GROUPS A AND B

CRUDE SCORE	GROUP A	GROUP B
18.............................	0	1
17.............................	3	5
16.............................	6	2
15.............................	3	10
14.............................	14	10
13.............................	15	13
12.............................	33	20
11.............................	22	13
10.............................	18	8
9.............................	12	10
8.............................	7	7
7.............................	9	3
6.............................	5	7
5.............................	5	3
4.............................	7	2
3.............................	0	2
2.............................	3	5
1.............................	1	2
0.............................	0	1
Number of Cases...............	163	124

The two groups were of practically equal mental maturity, as was indicated by their equal mean crude intelligence scores.

TABLE III
Chronological Ages of Pupils in Groups A and B

Chronological Age (Years)	Group A	Group B
14	12	10
13	37	25
12	26	31
11	54	25
10	34	33
Number of Cases	163	124

They were of practically equal chronological ages, the means differing by only one day. They were of practically equal native intelligence, each group having an intelligence index of 90.6.

No one has yet proved that innate capacity for learning has been measured when the best intelligence test known has been administered. With such a measure, one may possibly be about halfway between a measure of the effects of biological inheritance and the effects of surroundings and experience.

In all likelihood, there was no significant difference in the intelligence of the equated groups. Any discovered differences in the relative achievement of these two groups of pupils can therefore not be ascribed to a difference in intelligence.

CHAPTER VI

ACHIEVEMENT IN SCHOOL SUBJECTS

Were the Higher-Expenditure Schools Superior in Reading Accuracy?

THE first section of the battery of achievement tests was designed to secure measurements of accuracy in reading. The items of this section of the tests were arranged in the order of increasing difficulty. The scores represented the total number of correct answers.

The pupils of the higher-expenditure schools were found to be somewhat superior in their accuracy of reading. The tested pupils of Group A made a mean score of 3.92 as against a mean score of 3.79 for the pupils of Group B. The difference of 0.13 between the mean scores of these two groups of pupils indicates an equated difference of .17 of one year. This means that on the whole, it would take the pupils of Group B an additional 0.17 of one year to make sufficient gains at their rate of improvement to bring them up to the level held by the pupils of Group A at the time of the testing.

The equated difference was computed by taking the difference of the two means, dividing by the smaller of these two means, and multiplying by 5 years. These pupils averaged 11 years of age; they had probably been in school for about 5 years. This, then, had been the approximate length of time during which this achievement retardation of the pupils of Group B had accrued.

The reliability of the difference found between the relative mean achievement scores of Groups A and B in the accuracy of reading test, is indicated by the E.C. (experimental coefficient) of .29 to be about 3 chances to 1. Statistically, the experimental coefficient is the ratio of the difference between means of two groups on any item measured to 2.78 times the S.D.diff. (standard error of this difference). In formula* this becomes:

$$\text{E.C.} = \frac{\text{Mean of } A - \text{Mean of } B}{2.78 \text{ S.D.diff.}}$$

*See W. A. McCall, *How to Measure in Education*, pp. 404–05. The Macmillan Company, 1922.

Where the E.C. is 1, the reliability of the difference is regarded as practically certain; the statistical measure of reliability may be expressed as 369 chances to 1. When the E.C. is 0.5, the chances of reliability are 11 to 1, and when the E.C. is zero, the chances of reliability of the obtained difference are even or 1 to 1. In common parlance, the chances are then fifty-fifty.

Significance is decidedly a relative matter and ranges all the way from approximate zero to very near certainty.

Did the Higher-Expenditure Schools Make Any Better Showing in Spelling?

The items of the spelling section of the tests used were arranged in the order of increasing difficulty; the scores represented the number of words spelled correctly.

The pupils of Group A made a mean spelling score of 2.67 as against a mean score of 2.37 for Group B. The difference between these two means is .30; the equated difference is .63 of one year. The reliability of this difference shows an E.C. of .53, which indicates about 13 chances to 1. In other words, the measures indicate that after having spent five years in below-median expenditure schools such as those of Group B, the pupils will have fallen so far behind the pupils of such schools as those of Group A, that it would take them at their rate of improvement 0.63 of another year to come up to the level held by the pupils of Group A at the time of the spelling test.

Did the Higher-Expenditure Schools Secure Greater Comprehension in Reading?

In the reading comprehension section of the test, the items were arranged in the order of increasing difficulty; the scores represented the number of correct responses.

The pupils of Group A made a mean reading comprehension score of 4.88 as against a mean score of 4.61 for Group B. The difference of .27 between these two means was in favor of the higher-expenditure schools, and the equated difference was .29 of one year. The E.C. of .33 indicates chances of about 4 to 1 that the difference is reliable. The measures indicate that pupils attending such schools as those of Group B will show a .29 year learning lag in reading comprehension at the end of five years, as compared to pupils in such schools as those of Group A.

Did the Higher-Expenditure Schools Promote Better Language Usage?

The items of the language usage section of the tests used were arranged in order of increasing difficulty; the scores represented the number of correct answers.

The pupils of Group A made a mean score of 2.08 as against a mean score of 2.04 in Group B. The equated difference was but .09 of one year, and was indicated by the small E.C. of .10 to have but 1.6 chances to 1 of being a reliable difference. This represents the slightest difference between the mean scores of Groups A and B discovered up to this point.

Did the Higher-Expenditure Schools Secure Any Higher Level of Health Knowledge?

The items of the health knowledge section of the tests used were about on a par in relative difficulty. The scores represented the number of correct answers.

In this test, the pupils of Group A made a mean score of 4.09 as compared with a mean score of 3.82 for the pupils of Group B. The equated difference indicates .35 of one year retardation in the learning of the pupils of Group B, the lower-expenditure schools. The E.C. of .53 indicates that the chances of reliability of the difference are 13 to 1.

Did the Higher-Expenditure Schools Secure Any Greater Average Achievement in History and Civics?

In the history and civics section of the tests used, the questions were arranged in the order of increasing difficulty. The scores represent the total number of correct responses.

In this test pupils of Group A made a mean score of 2.64 as against one of 2.31 for Group B. The difference between mean scores is .33, the equated difference is .71 of one year, and the E.C. is .79. This is the largest difference so far found between these two groups of pupils. The lower-expenditure school pupils were retarded by .71 of one year in five. The larger E.C. of .79 indicates relatively high reliability of this difference. The chances are 73 to 1 that in any two larger groups of schools comparable to Groups A and B, the higher-expenditure school pupils would be superior in history and civics.

Did the Higher-Expenditure Schools Secure Greater Average Achievement in Geography?

The items of the geography section of the tests used were arranged in the order of increasing difficulty; the scores represented the total number of correct answers.

In this test the pupils of Group A made a mean score of 3.00 and the pupils of Group B made a mean score of 2.80. The difference of .20 in favor of the pupils of Group A has 5 chances to 1 of being reliable, as is indicated by the E.C. of .37. The equated difference is .35, which indicates that the pupils of Group B were .35 of one year behind the pupils of Group A in achievement in geography at the time of the administering of these tests.

Did the Higher-Expenditure Schools Secure Any Greater Average Achievement in Elementary Science?

The eighth measure was made to determine the relative achievement of the two groups of pupils in elementary science. The items of this section of the test used were arranged in the order of increasing difficulty; the scores represented the total number of correct answers.

The mean score for Group A was 1.71 and the mean score for Group B was 1.57. The difference between the means was .14. The equated difference was .44 of one year, and the E.C. was .38, which indicates 6 chances to 1. The pupils of the lower-expenditure schools were retarded to the extent that it would take them .44 of another school year to make sufficient gains to bring them up to the level held by pupils of the higher-expenditure schools at the time of the tests.

Were the Higher-Expenditure School Pupils Superior in Arithmetic?

The items of the arithmetic section of the tests used were arranged in the order of increasing difficulty in each of two sections of this part of the tests. The scores represented the number of correct answers.

In arithmetic, the pupils of Group A made a mean score of 3.70 as against a mean score of 3.37 for Group B. The difference of .33 between these two mean scores gives 13 chances to 1 of being reliable, as is indicated by the E.C. of .53. The equated difference shows that the pupils of the lower-expenditure schools were

.48 of a year behind the pupils of the higher-expenditure schools in average achievement in arithmetic at the time the tests were given.

Were the Higher-Expenditure School Pupils Superior on the Whole?

In the nine different phases of school achievement which were measured in this investigation, the pupils of the higher-expenditure schools were found superior to the pupils of the lower-expenditure schools. They were most superior in history and civics, arithmetic, and elementary science; they were least superior in language usage and reading. A total achievement score was computed for each pupil by taking the sum of the nine different scores made by that pupil in the nine subject tests.

While the total achievement score is taken as the sum of the nine different subject test scores, the relative weighting of these nine scores is not exactly equal but is in proportion to the size of standard deviation of the distribution of scores made in each subject test. The weightings are as follows: reading accuracy, 1.27; spelling, 1.89; reading comprehension, 2.62; language usage, 1.31; health knowledge, 1.66; history and civics, 1.28; geography, 1.89; elementary science, 1.19, and arithmetic, 2.20; or in whole numbers the weightings are approximately 8, 12, 17, 9, 11, 8, 12, 8, and 14. The heaviest weightings of 17 and 14 are on reading comprehension and arithmetic.

In total achievement the pupils of Group A made a mean score of 28.73 as compared with a mean total achievement score of 26.72 made by the pupils of Group B. The difference of 2.01 between these two mean scores gives 15 chances to 1 that it is a reliable difference, as is indicated by the E.C. of .55.

In the general average achievement in school subjects, the pupils of the lower-expenditure group of schools were behind the pupils of the higher-expenditure group by about .37 of one year in five.

Table IV shows that higher average achievement of school pupils and higher average school expenditures were found together in each of these nine different tests.

In other words, there are a little over 93 chances out of every 100 that the true difference between any two larger groups of schools comparable to Groups A and B of this study is in favor of the higher-expenditure schools. There are 93 chances out of

every 100 that the schools such as those of Group A, representative of the one-teacher schools with expenditures averaging above the median for the whole state, are securing greater average achievement in the school work of their pupils than are the schools in which the average expenditures are below the median for the state.

TABLE IV

MEAN ACHIEVEMENT MEASURES OF THE TWO GROUPS OF SCHOOLS

ABILITY MEASURED	GROUP	MEAN	S.D.	S.D. M	DIFF.	S.D.diff.	E.C.	EQUATED DIFF.	CHANCES OF RELIABILITY
Reading Accuracy	A.....	3.92	1.58	.12	.13	.16	.29	.17	3 to 1
	B.....	3.79	1.41	.12					
Spelling	A.....	2.67	1.69	.13	.30	.20	.53	.63	13 to 1
	B.....	2.37	1.94	.17					
Reading Comprehension	A.....	4.88	2.62	.20	.27	.29	.33	.29	4 to 1
	B.....	4.61	2.54	.22					
Language Usage	A.....	2.08	1.21	.09	.04	.14	.10	.09	8 to 5
	B.....	2.04	1.28	.11					
Health Knowledge	A.....	4.09	1.51	.11	.27	.18	.53	.35	13 to 1
	B.....	3.82	1.73	.15					
History and Civics	A.....	2.64	1.21	.09	.33	.15	.79	.71	73 to 1
	B.....	2.31	1.36	.12					
Geography	A.....	3.00	1.79	.14	.20	.19	.37	.35	5 to 1
	B.....	2.80	1.49	.13					
Elementary Science	A.....	1.71	1.20	.09	.14	.13	.38	.44	6 to 1
	B.....	1.57	1.16	.10					
Arithmetic	A.....	3.70	2.19	.17	.33	.22	.53	.48	13 to 1
	B.....	3.37	1.74	.15					
Total Achievement	A.....	28.73	10.95	.85	2.01	1.03	.55	.37	15 to 1
	B.....	26.72	11.02	.99					

CHAPTER VII

HAPPINESS SCORES

Were the Higher-Expenditure School Pupils Happier Students?

THE McCall *Preliminary Happiness Test* section of the tests was used for the measurement of school happiness. The items of this section were arranged in the order of practically equal difficulty, and the scores represented the sum of the number of positive responses for the first group of questions plus the sum of the number of responses for the remainder of the test.

The pupils of Group A made a mean happiness score of 9.36 as against a mean score of 8.59 for Group B. In the children's happiness in their school surroundings there was a difference between the means of these two groups of 0.77, the reliability of which difference was indicated by the E.C. of .53 to be 14 chances to 1. That is, there are 14 chances to 1 that children while attending one of the one-teacher schools of the upper-expenditure group will be more happy in their school work than will the children who attend one of the schools of the lower-expenditure group. Table V gives the average happiness scores.

TABLE V

AVERAGE HAPPINESS SCORES

GROUP	MEAN	S.D.	S.D.M	DIFF.	S.D.diff.	E.C.	CHANCES OF RELIABILITY
A.........	9.36	4.46	.34				
				.77	.51	.53	14 to 1
B.........	8.59	4.36	.34				

The two groups of pupils show a difference in the mean happiness scores consistent with the relative standings of these groups in every other measure so far reported in this investigation. Pupils of Group A were happier in school than were the pupils of Group B. General happiness and successful school achievement

may be closely interrelated, each tending to promote the growth of the other.

This happiness test, to a large degree, gives a measure of the child's all-round satisfaction and contentment in school, and his enthusiasm for the school he attends. It is a sort of measure of his adjustment to school life and of the degree of his preference for days spent in school to time otherwise occupied.

The child's reactions to the question "Which would you rather do: go to school to-morrow or play you are grown up? talk with a grown person whom you like? read stories of adventure? do any-thing—daydream? play with pets? give a circus? have poetry read to you? stay in bed all day? etc.," do to a certain extent show his relative like or dislike for school.

It would seem reasonable to assume that, other things being equal, the school which best adjusts itself to the child will most certainly kindle and tend to hold the child's interest in school work, and thus make for greatest achievement, and for a more natural, probably longer continued, and less artificial educational growth.

CHAPTER VIII

ADEQUACY OF MEASURES

Could the Obtained Superiority of the Higher-Expenditure Schools Be Ascribed to Inadequacy of Measures?

In large unselected groups of rural school children, the measurement of only 12-year-old children gives a fair picture of the group as a whole. Where numbers are smaller, the measurement of 10-, 11-, 12-, 13-, and 14-year-old children is more practical.

Completeness of measurement was in this investigation impossible and unnecessary. Measurement in a sampling of traits would seem to give a fairly accurate picture of the relative progress of the two groups of pupils on the whole. Good things in education have been found to go pretty much together, and it is probable that measurement in even fewer traits would have given a fairly true picture of the relative learning of these two groups of pupils.

There is good reason to believe that, even when the child has been measured laboriously and extravagantly and extensively, every year or oftener, in every part of every subject about which he knows or possibly ought to know anything, the resulting picture is no truer than that which could have been obtained from the measurement of the same child, with a representative sampling of items from the whole array of tests. This was the point of view which was taken in the arrangement of tests for this investigation.

The claim to fairness is strengthened by the following facts: the tests were administered at the school buildings, by trained and experienced persons; each pupil was measured in his own school and under conditions most conducive to fair measurement; uniform procedure was maintained throughout, and all tests were scored with the aid of trained assistants and were checked and rechecked by the author. The fact that whatever was measured by the use of these tests in the one group of schools was the same as that measured in the other group of schools tended to place the different groups of schools on common ground for comparison.

24

Moreover, the items measured were most likely a fair sampling of the total educational changes in process in these schools.

No one is more aware than is the writer of possible shortcomings of these tests. Not everything in which there were educational changes taking place in these pupils was measured. Nor any trait or achievement measured with 100 per cent accuracy. Only 10-, 11-, 12-, 13-, and 14-year-old pupils were measured, and these in only a sampling of traits, and by the use of abridged tests.

CHAPTER IX

DIFFERENCES WITHIN GROUPS

Were There Differences Within as Well as Between the Two Groups of Pupils?

THE total achievement differences were even greater within the groups than were the differences between the two compared groups of schools. Group A was divided at the $1,800 expenditure level into Subgroup 1, to include those schools with expenditures from $1,800 up to the highest expenditures found in the whole group of schools studied, and Subgroup 2 with expenditures from $1,800 down to $1,500. Group B was divided at the $1,300 expenditure level into Subgroup 3, to include schools with expenditures from $1,500 down to $1,300 and Subgroup 4 to include those schools with expenditures of less than $1,300. Table VI, page 28, shows the expenditures and the achievement scores for these four groups.

The mental ability was practically equal, group for group. A small part of any intergroup differences in achievement may possibly be due to intelligence differences not entirely leveled out in the equating of the two major groups, A and B.

The average achievement scores for Subgroups 1, 2, 3, and 4 were respectively 30.54, 28.16, 27.71, and 23.70. The average expenditures for these subgroups were $2,130, $1,594, $1,402, and $1,204.

When Expenditures Differed by as Much as $900, Did the Higher-Expenditure Schools Secure the Greater Returns?

Pupils of Subgroup 1 made an average total achievement score of 30.54 as against an average score of 23.70 for Subgroup 4. The equated difference indicates that it would take the pupils of Subgroup 4 an additional 1.44 years, at their rate of improvement, to make sufficient gains to bring them up to the achievement level held by the pupils of Subgroup 1 at the time of the tests. This means that the pupils of the lowest-expenditure schools were

found to be retarded 1.44 years in five, as compared to the pupils in the highest-expenditure schools of this investigation.

The mean total achievement scores of Subgroups 1 and 4 (30.54 and 23.70) show a difference of 6.84. The chances of the reliability of this difference are indicated by the E.C. of 1.03 as 499 chances to 1, or more than what is commonly accepted as practical certainty.

The expenditures of Subgroup 1 averaged $2,130 and the expenditures of Subgroup 4 averaged $1,204, showing a difference of $926. All schools of Subgroup 1 made expenditures of more than $1,800 and all schools of Subgroup 4 made expenditures of less than $1,300.

There are, according to these data, 998 chances out of every 1,000 that a child would learn more in the higher of two groups of such schools where the expenditures differ by $926.

When Expenditures Differed by as Much as $700, Did the Higher-Expenditure Schools Secure the Greater Returns?

Subgroups 1 and 3 show a difference in expenditure of $728 ($2,130–$1,402) and a difference in achievement scores of 2.83 (30.54–27.71). The reliability of the achievement difference of 2.83 is indicated by the E.C. of .58 as about 18 chances to 1.

The equated difference of .51 of one year indicates the degree of learning lag on the part of the pupils of Subgroup 3 as compared with the pupils of Subgroup 1, who had attended schools where the expenditures were higher by $728 annually.

A difference of $700 in expenditures is positively associated with a difference in the average achievement of the pupils. A difference of $900 is positively associated with a greater difference in the average achievement of the pupils than was found where expenditures differed by but $700.

The chances of reliability of the obtained achievement difference between the two groups are practically certain, 499 to 1, where the expenditures differed by $900 and are 18 chances to 1 where they differed by $700.

When Expenditures Differed by as Much as $500, Did the Higher-Expenditure Schools Secure the Greater Returns?

Subgroups 1 and 2 differed in expenditures by $536 ($2,130–$1,594) and in the total achievement scores by 2.38 (30.54–28.16).

The E.C. of .53 indicates a reliability of difference of about 13 chances to 1.

The equated difference of .42 of one year indicates that the pupils of Subgroup 2 were retarded by .42 of one year in five as compared to the rate of progress of the pupils in the schools of Subgroup 1, where the expenditures were higher.

A difference in expenditures of $500 is positively associated with a difference in the achievement of the pupils; a difference in expenditures of $700 is positively associated with a greater achievement difference, and a more reliable difference. A difference in expenditures of $900 is positively associated with a still greater achievement difference and with a difference, the reliability of which is more than practically certain. Data presented in Table VI reveal the relationship between expenditures and achievement in the four subgroups of schools.

TABLE VI

EXPENDITURES AND ACHIEVEMENT IN THE FOUR SUBGROUPS OF SCHOOLS

SUBGROUP	MEAN EXPEN-DITURES	MEAN ACHIEVE-MENT	S.D.	S.D.M	DIFF. FROM MEAN-1	EQUATED DIFF.	S.D.diff.	E.C.	CHANCES OF RE-LIABILITY
1..........	$2,130	30.54	9.77	1.34					
2..........	1,594	28.16	10.04	.88	2.38	.42	1.60	.53	13 to 1
3..........	1,402	27.71	10.93	1.12	2.83	.51	1.75	.58	18 to 1
4..........	1,204	23.70	10.83	1.47	6.84	1.44	2.38	1.03	499 to 1

In summary, the mean achievement of pupils and mean expenditures of the schools they attend were found in this investigation to rise and fall together. The greater the difference in expenditures the greater was the difference found in achievement in this type of schools.

CHAPTER X

DOLLAR-FOR-DOLLAR RETURNS

Dollar for Dollar, Did the Higher-Expenditure Schools Secure the Greater Returns?

In the county of this investigation, those schools with average expenditures of less than $1,300 were securing but 59 cents returns on the dollar expended, as compared to the returns obtained in the school districts averaging over $1,800 in their expenditures.

To take from the lowest-expenditure schools a large part of the buying power of what few dollars they do spend places a double handicap upon the pupils of these schools.

Children learned more on the average in the schools where the expenditures were greater. The per-pupil units of achievement on the dollar, in the schools of Subgroups 1, 2, 3, and 4 were .0143, .0182, .0197, and .0196 in the order named. This might at first appear to be a case of diminishing returns. The figures given were obtained by dividing the average total achievement score for the group of schools by the average expenditure for that group, ignoring totally the question of how many pupils per school were brought up to their level of achievement by means of current average expenditures in that group of schools.

The sum total of learning in any school is dependent upon the number of pupils who learn and upon how much each one of these pupils learns. One measure of the educational returns on the dollar in any particular school would be the total learning of the pupils attending that school, divided by the number of dollars expended in that district.

The average number of pupils enrolled, times their average achievement, divided by the average expenditures, will give, for comparative purposes, a measure of the educational returns in any school per dollar expended. The average number of pupils enrolled in the schools of Subgroups 1, 2, 3, and 4 was 23, 18, 13, and 10 in the order named. Table VII shows the corresponding returns for these groups.

TABLE VII

THE BUYING POWER OF THE DOLLAR

SUBGROUP	MEAN ENROLL-MENT	MEAN ACHIEVE-MENT	MEAN EXPEND-ITURE	RETURNS	
1..............	23	30.54	$2,130	$\dfrac{23 \times 30.54}{2,130} = .329$	$1.00
2..............	18	28.16	1,594	$\dfrac{18 \times 28.16}{1,594} = .317$.96
3..............	13	27.71	1,402	$\dfrac{13 \times 27.71}{1,402} = .266$.80
4..............	10	23.70	1,204	$\dfrac{10 \times 23.70}{1,204} = .196$.59

In order to increase the amount of returns in any school, $\dfrac{\text{Average Achievement Times Enrollment}}{\text{Expenditure}}$, there must be a raising of the achievement level, an enlargement of the enrollment, or a decreasing of the expenditures. Any one or more of these changes might increase the returns.

Would a Decrease in Expenditures Increase the Educational Returns on the Dollar?

To the extent that a decrease in expenditures can be made without a corresponding lowering of the average achievement of the pupils, educational returns on the dollar could thus be increased. In general and as forces have been operating, a decrease in average expenditures has been found positively associated with, and therefore overbalanced by, a relative decrease in achievement. This can not be accepted, as returns on the dollar would thus not be at all increased, and the individual pupil would in turn learn less effectively.

Would Increasing the Average Achievement Increase the Returns?

To secure an increase in returns on the dollar by raising the average achievement level, the enrollment remaining constant, the expenditures may not be increased more, proportionately, than is the achievement of the pupils. To the extent that funds avail-

able can be more effectively managed, returns may thus be increased.

Would Enlarging the Enrollment Increase the Returns Per Dollar?

Larger enrollment has been found conducive to greater average achievement, and is especially desirable where enrollments are too small for fair returns. An increase in both enrollment and achievement will increase the returns on the dollar.

Larger enrollments in schools make higher expenditures imperative; it costs more to operate a larger school, it takes a better teacher, more working equipment, supplies, and the like. But these higher expenditures are made with a correlative saving in per-pupil costs and with an increase in the average achievement of the pupils.

The very small enrollments in many rural schools tend to go with lowered average achievement, and with excessively high per-pupil costs. The educational returns on the dollar of expenditures are deplorably low in such schools as those of Subgroup 4. This subgroup is getting but 59 cents on the dollar as compared to what has been demonstrated as possible to attain in the same county. Moreover, when compared to anywhere near optimum conditions, these schools are, beyond any possible question, getting much less than this 59 cents on the dollar. It would be absurd to assume that the relatively higher returns of the Subgroup 1 schools are nearly as high as they could be made. There is, in fact, more good reason to believe the opposite is true.

CHAPTER XI

INDIRECT MEASURES AND EXPENDITURES

Are There Possible Indirect Measures Which Explain the Returns?

WHILE the pupils were being tested in the different schools, certain more or less indirect measures of returns were also taken for whatever further light they might shed upon the question as to how schools differ as expenditures change. Data were obtained on the number of years' training beyond high school, the number of years of previous teaching experience of the teacher, the salary of the teacher, the number of pupils enrolled, and the score of the buildings and grounds. Table VIII gives these complete data for Groups A and B.

The district-weighted means of expenditures and district-weighted means for teacher training, experience, and salary, for enrollment, and for the building and grounds score are probably the best measures here made for comparing district with district or for comparing any two groups of schools on these particular items. But in considering the effect of any one of these variables, or any combination of them, upon pupil achievement, the two must be weighted in like manner. For doing this, the pupil-weighted average may be used more effectively. The district-weighted mean in teacher experience for Group A, for example, is merely the sum of the 35 individual teacher experience measures, divided by 35, the number of teachers in this group. In Group A, the total 364 divided by 35 gives 10.4 years as the average number of years of teaching experience of the teachers of this group of schools.

The computation of the pupil-weighted average has already been described in Chapter III.

From the evidence uncovered in this investigation, it is established with practical certainty that in one-teacher schools, educational expenditures and educational returns in the form of actual pupil achievement do rise or fall together. The higher the expenditures, the higher are the returns. *To get the facts on this*

TABLE VIII

GROUP MEANS ON INDIRECT MEASURES

ITEM MEASURED	GROUP			SUBGROUP				M_1–M_4
	A	B	DIFFERENCE	1	2	3	4	
Teacher Training								
District Wtd.	1.62 yrs.	1.56 yrs.	.06 yr.	1.1 yrs.	1.7 yrs.	1.5 yrs.	.88 yr.	.22 yr.
Pupil Wtd.	1.39	1.77	-.38	.69	1.5	1.9	.46	.23
Teacher Experience								
District Wtd.	10.4 yrs.	6.2 yrs.	4.2 yrs.	10 yrs.	10 yrs.	4.5 yrs.	8 yrs.	2 yrs.
Pupil Wtd.	11.4	6.6	4.8	17.3	10	5.3	10.3	7
Enrollment								
District Wtd.	18	12	6	23	18	13	10	13
Pupil Wtd.	23	16	7	31	20	17	13	18
Teacher Salary								
District Wtd.	$1,204	$1,031	$173	$1,314	$1,243	$1,128	$1,012	$302
Pupil Wtd.	1,276	1,098	178	1,374	1,252	1,141	976	398
Buildings Score								
District Wtd.	343	268	75	405	325	269	248	136
Pupil Wtd.	313	233	80	381	296	243	201	180

point was the main purpose of this investigation. With these facts at hand, we may investigate further the question of how higher expenditures really make possible the higher returns. Expenditures in themselves are, of course, not directly causal. It becomes a question of what the higher expenditures do bring in higher degree, and which of these factors obtained in higher degree might possibly be more directly responsible for the higher achievement of the higher-expenditure school pupils. There is the possibility of higher salaries, and perhaps better teachers with more training for their work, and possibly with more previous experience in teaching, and possibly more able to successfully direct the learning of larger groups of pupils. There is also the possibility of better buildings and grounds with better teaching equipment, etc. It might be interesting to know whether or not the higher expenditures do bring any of these items in higher degree, whether more money secures better trained teachers, better buildings, etc.

Did the Higher-Expenditure Schools Pay Higher Teacher Salaries?

Sixty-eight per cent of the expenditures in the schools of Group A and 77 per cent of the expenditures in Group B were for teacher salaries. The average current expenditures were, respectively, $1,746 and $1,337. The average teacher salaries were respectively $1,204 and $1,031. Out of the excess expenditure of $409, Group A paid an excess teacher salary of $173 over that paid by the schools of Group B. This merely means that 173/409, or about 42 per cent of the excess expenditure of Group A, went for higher teacher salaries than were paid in Group B. The remaining 58 per cent of the $409 excess expenditure was used for other purposes, including additional working equipment and improved care of buildings and grounds, as was indicated by the excess of 80 points in the total building and grounds score which was attained in Group A.

Did the Higher-Expenditure Schools Employ Better Trained Teachers?

The average teacher salary in Group A was $173 higher than that in Group B. Apparently, other things being equal, it takes relatively higher salaries to secure the services of more highly trained teachers. "The amount of . . . training is a major deter-

minant of salary. . . ."* In general it seems established that *higher teacher training is a correlate of higher expenditures.*

The district-weighted average length of teacher training was 1.62 years in Group A and 1.56 years in Group B, a small difference of .06 of one year. This becomes a negative difference when it is pupil-weighted, and is the only such difference found in the whole study. The higher salaries in the schools of Group A were evidently paid, for the most part, for something besides higher training of the teachers.

In several of the 70 different schools studied, there were teachers without training beyond high school, and some who had never finished or even started high school work. On the other hand, a few of these teachers had secured such training as to, in some degree, compensate for lack of college training. The majority of the teachers had done some college, university, or normal school work; a few held Bachelor's or Master's degrees.

The fact that the higher-expenditure schools where superior pupil achievement was the outcome, were directed by teachers with no more training, is in itself neither an argument for nor against such training. Teaching skill may have been built up through other influences as well. Moreover, had these teachers had further training, they might have been able to secure still more superior results.

Did the Higher-Expenditure Schools Employ More Experienced Teachers?

In this study, longer teaching experience was found to be directly associated with higher salaries and with higher expenditures. *The higher-expenditure schools employed more experienced teachers.* The district-weighted average number of years' previous teaching experience in the schools of Group A was 10.4 and 6.2 in Group B, a difference of 4.2 years in favor of the higher expenditure schools.

In several of the 70 different schools investigated, there were teachers employed who were just beginning in their professional work. In other schools there were teachers with from 20 to 30 years of previous experience; and one teacher had taught for 38 years.

*W. S. Elsbree, *Teachers' Salaries*, p. 56. Bureau of Publications, Teachers College, Columbia University, 1931.

Did the Higher-Expenditure Schools Have Larger Enrollments?

The average enrollment in the schools of Group A was 18 pupils and in the schools of Group B, 12 pupils; the average expenditures were $1,746 and $1,337. In the schools of Subgroups 1, 2, 3, and 4, the enrollments were, respectively, 23, 18, 13, and 10 pupils, and the average expenditures were $2,130, $1,594, $1,402, and $1,204 in the same order.

The following digression from the central thought will, it is hoped, help to connect these two points: There is reason to believe that the enrollment is an index of something additional and different in the teaching power and other desirable qualifications in the teacher. There may be certain desirable qualities of the teacher other than those most closely associated with the amount of training and experience. There may be those certain qualities of personality, of character, and ability which make a teacher best able successfully to direct the school activities of a large number of pupils.

The comments of those who employ the teachers in the county studied and of the teachers themselves who are employed in these schools, have led to the definite conviction on the part of the author that a different type of teacher is sought out and employed in the larger school; and that both the employers and the teacher recognize that teaching in one of the larger schools requires and demands better pay than teaching in a school where only a few pupils attend. *Employers expect to pay more, and to select their teachers more painstakingly where enrollments are large.* This difference in type of teacher is something apparently obtained with higher expenditures. The number of pupils enrolled might then be taken as the best index of these qualities in the teacher. There may also be some added stimulus to the learning of pupils in their association with larger groups of children. The size of the enrollment may therefore be taken as an index of such an influence upon the learning of the pupils.

Did the Higher-Expenditure Schools Have Higher Scoring Buildings and Grounds?

The district-weighted scores for building and grounds in Groups A and B were respectively 343 and 268; the expenditures were $1,746 and $1,337.

In Subgroups 1, 2, 3, and 4, the building scores were 405, 325,

269, and 248 in the order named; the expenditures were $2,130, $1,594, $1,402, and $1,204. The correlation between expenditures and the score of the building and grounds is plain from these facts.

Thus, from these analyses, higher teacher training, longer teacher experience, larger pupil enrollment, and higher scores on buildings and grounds are all shown to be directly associated with higher expenditures.

Evidence was presented in Chapters V to X inclusive and the fact was established that higher returns are correlative with higher expenditures. In this chapter, certain evidence has been presented and reviewed in an attempt to show certain factors which obviously influence the nature and degree of the resulting returns to be correlative with higher expenditures. These "in between" factors, such as teacher training, teacher experience, pupil enrollment, and building and grounds score, are obtainable in high or low degree accordingly as the expenditures are high or low.

Expenditures are, of course, not causal per se. They are indirectly causal in so far as, with expenditures, any of the more direct causal factors may be obtained. Some of these factors may be more directly causal than others and to a greater degree; any of them here considered may be more directly causal than are expenditures as such.

In an investigation of this sort, of course, the identity of the minute and elemental causes of higher returns can not be established with absolute certainty. Certain of the more plausible and striking factors can be isolated and shown, in the light of all evidence uncovered, to be likely to prove highly productive of educational returns.

With the correlation between higher expenditures and higher returns more or less established, and then the correlation between higher expenditures and certain "in between" influencing factors such as higher teacher training, longer teacher experience, larger pupil enrollment, and higher scoring buildings and grounds also pointed out, the next step is to learn the real relationship between these "in between" influences and the actual returns.

CHAPTER XII

INDIRECT MEASURES AND RETURNS

Did Higher Teacher Training Bring Higher Pupil Achievement?

HIGHER expenditures have been shown to bring higher returns. Higher expenditures have also been shown to bring higher average training and experience of teachers together with larger pupil enrollment and higher scoring buildings and grounds. The influence of these factors upon achievement, if known, might point to improved utilization of funds.

Of all the different factors measured in this investigation as possible influences in pupil achievement, the only measure in which the higher-expenditure schools averaged less than did the lower-expenditure schools was in the pupil-weighted average number of years' training of teachers. The average number of years' training beyond high school was 1.39 for teachers of Group A and 1.77 for teachers of Group B. The higher-expenditure schools were employing teachers with a pupil-weighted average of .38 of one year less training than those in the lower-expenditure schools.

The higher-expenditure schools were securing higher average pupil-achievement and higher educational returns generally. Could this be because of their lower average training of teachers? Or was it accomplished in spite of lower teacher training?

Were the analysis to be left at this point, the conclusion might be that higher average pupil achievement, and school happiness as well, do sometimes come even when average teacher training is lower. It might even appear that the training commonly received by teachers is not especially helpful; or it might be charged that teacher training is even detrimental to a certain degree.

The lower-expenditure schools with teachers of higher training were not superior, not even equal, but decidedly inferior, to the higher-expenditure schools. The lower-expenditure schools secured an inferior achievement and lower returns apparently in every sense of the word. There must, of course, be other influ-

encing elements entering into the obtaining of good educational returns besides this one of training. If training does not function as an aid for good teaching—what a predicament we are in, both as students and teachers! Does training count?

In an attempt to better test the relation between teacher training and pupil achievement, the higher-expenditure groups and lower-expenditure groups were equated as to relative amounts of training of their teachers. This equating did not change, to any great extent, the relative weighting of the other measured variables, such as the amounts of previous teaching experience, pupil enrollments, and the like.

The difference between the two groups, A and B, was not large to begin with. The teachers of Group A averaged .38 of one year less training each than did the teachers of Group B, the lower-expenditure schools. In other words, the equated difference in teacher training of .27 indicates that the schools of Group A were directed by teachers with 27 per cent less training beyond high school than were the schools of Group B.

Of the 163 pupils of Group A, 63 had been under the instruction of teachers with no training beyond high school. Without changing the achievement average of these 63 cases, 35 were discarded. This brought the number of cases remaining in Group A down to 128 and the average amount of training of teachers in this group up to 1.77 years. It was 1.77 years in Group B in the first place. Groups A and B then had equal average training of teachers. What was the resulting effect upon the earlier found difference between these two groups in average pupil achievement? Table IX shows the average pupil achievement of Groups A and B before being equated.

TABLE IX

Groups A and B Before Being Equated on Indirect Measures

Group	No. of Cases	Mean Achievement	S.D.	S.D.м	Diff.	S.D. diff.	E.C.	Chances of Reliability	Expenditures
A.........	163	28.73	10.95	.85					$1,703
					2.01	1.30	.56	15 to 1	
B.........	124	26.72	11.02	.99					1,354
									$ 349

Group A and Group B before being equated on teacher training, showed average total achievement scores of 28.73 and 26.72, respectively. Equated on teacher training, the groups showed average total pupil achievement scores of 29.07 and 26.72. The excess in favor of Group A was thus increased from 2.01 to 2.35. The reliability of the new difference was also greater. In the former difference, the chances of reliability were 15 to 1. After the groups were equated on teacher training, the chances were 30 to 1. These facts are revealed in Table X.

TABLE X

GROUPS A AND B EQUATED ON TEACHER TRAINING

GROUP	NUM-BER OF CASES	MEAN ACHIEVE-MENT	S.D.	S.D.M	DIFF.	S.D. diff.	E.C.	CHANCES OF RELIA-BILITY	EXPENDI-TURES
A......	128	29.07	9.14	.80					$1,647
					2.35	1.27	.66	30 to 1	
B......	124	26.72	11.02	.99					1,354
									$ 293

The superiority of Group A before and after equating with Group B on teacher training may be shown in another way. The two groups at first showed a pupil achievement retardation of .37 of one year in five for Group B. When the groups were equated on training, the retardation increased to .44 of one year in five.

With lower average teacher training, the pupils of Group A exceeded the pupils of Group B by .37 of one year in five; with equal average teacher training, the pupils of Group A exceeded the pupils of Group B by .44 of one year in five. What would have been the resulting difference, other things being equal, had the schools of Group A employed teachers with greater training than was the case in Group B?

It is a logical conclusion that, in such a case, the Group A children would to a still greater extent lead the children of Group B. In other words: It is probable that the schools now securing the highest average pupil achievement could, with a raised standard of teacher training, do still better.

The fact of less training did not make the higher-expenditure school teachers superior—they were probably superior in the first place, and for other reasons—but perhaps the lack of training

kept them from being still more superior. Other factors must then have been operating.

A better way of determining the correlation between teacher training and pupil achievement would, of course, be to take the higher and lower teacher training halves of the studied schools as two new groups regardless of expenditures, and to compare these two new groups in relative pupil achievement. The method here used seemed to establish the fact of such high correlation between training and achievement that such a regrouping did not appear necessary.

From the standpoint of expenditures, this investigation has shown that amounts of expenditures are in direct relation to the amounts of teacher salaries; that, other things being equal, it takes relatively higher salaries to secure the services of more highly trained teachers; and that higher teacher training brings higher pupil achievement.

Does Longer Teaching Experience Bring Higher Pupil Achievement?

In the whole group of 70 measured schools, there was found a wide variation in the previous experience of the teachers employed. Some of the teachers were just beginning in their profession, and other teachers had taught from 20 to as many as 38 years. The average length of previous experience of teachers in Group A was 11.4 years and in Group B, 6.6 years, the former exceeding the latter by 4.8 years. These facts are shown in Table VIII, page 33.

The schools of Group A during the five years preceding the investigation, had been securing higher average achievement of pupils than had the schools of Group B. The difference in achievement scores between these two groups of schools, when equated in the training of their teachers, was 2.35. When Group A was further equated with Group B on experience of teachers, the excess in pupil achievement score dropped to 1.16. See Table XI.

The probable conclusion, therefore, is that the longer teaching experience of the teachers of Group A must have been one contributing factor to the superiority of the higher-expenditure schools, and therefore, there is a direct association between teacher experience and pupil achievement. There may, of course, be a limit beyond which this statement is not true, but as the evidence stands the teacher of longer experience was securing superior results.

TABLE XI

GROUPS A AND B EQUATED ON TEACHER EXPERIENCE

GROUP	MEAN ACHIEVEMENT	S.D.	S.D.M	DIFF.	E.C.	CHANCES OF RELIABILITY
A...............	28.37	9.28	1.01			
B...............	27.21	9.09	.99	1.16	.307	4 to 1

Did the Schools with Larger Enrollments Secure Higher Pupil Achievement?

The variation in enrollment was wide. Some schools had as few as 3 pupils, and others as many as 55 pupils. There is an upper limit to the number of pupils for one school beyond which there may be expected diminishing educational returns and undue professional and physical strain upon any one teacher. One such school was found in this study and many schools were found that were altogether too small in enrollments.

There are, in New York State, 21 different schools being maintained with one pupil each, there are 67 more schools with two pupils each, there are 171 more schools with three pupils to the school, 222 schools with four pupils to the school, and 268 schools with five pupils. More than 2,700 districts out of the total 7,059 one-teacher districts in New York State have from 1 to 10 pupils. The pupil-weighted average enrollment in the higher-expenditure group was 23 and in the lower-expenditure group, 16. The excess pupil-weighted enrollment in favor of Group A was 7.

The higher-expenditure schools were superior in securing returns in pupil achievement and general school happiness. The fact that we start at the same place each time in equating, whether it be upon training, experience, or something else, makes it necessary to repeat the fact that the achievement score excess of Group A over Group B was 2.35 when the two groups were equal in teacher training, and Group A higher in all other measures.

Among other differences between these two groups of schools was an excess of 7 pupils in enrollment. Higher enrollment as such may not be directly causal, though *there may be*, as was pointed out earlier, *some degree of added stimulus to learning from the effect of association with more children*. More than this, *there*

may be certain superior qualities in the type of teacher commonly employed to direct the larger school. The enrollment may be a sort of two-way index of returns.

When the two groups were equated on enrollment, the excess in achievement for Group A dropped from the difference of 2.35 to a much smaller difference of 1.24. The average achievement score after the equating of enrollment was 28.68 for Group A and 27.44 for Group B. The reliability of this smaller achievement difference of 1.24 was but 5 chances to 1, in contrast to a reliability of 30 to 1, for the former difference. (See Table XII.)

The number of pupils enrolled in the school must have been at least indicative of some factors contributing to the superiority of the higher-expenditure schools. Although their enrollments were larger, the schools of Group A were superior to those of Group B in securing higher achievement of pupils. When the two groups were equated on enrollment, Group A was much less superior than before.

The probable conclusion is that there is a direct relation between pupil achievement and pupil enrollment under conditions prevailing in one-teacher schools.

TABLE XII

GROUPS A AND B EQUATED ON ENROLLMENT

GROUP	MEAN ACHIEVEMENT	S.D.	S.D.M	DIFF.	S.D. diff.	E.C.	CHANCES OF RELIABILITY
A........	28.68	8.89	.90	1.24	1.32	.33	5 to 1
B........	27.44	9.56	.97				

Were the Higher Scores on Buildings and Grounds Indicative of Higher Pupil Achievement?

The average building and grounds score was higher for the schools of Group A. The achievement score excess of Group A, as all influencing factors were operating at the time of the tests, stood at 2.01. When the two groups had been equated on building and grounds scores, but not equated on teacher training or other factors, the excess in achievement scores dropped to 1.73. Higher building and grounds scores and superior pupil achievement were found together in the higher-expenditure schools.

The building and grounds score, like training, experience, and enrollment, seems to be correlative with achievement, though to a relatively small degree; the drop in the achievement score excess of Group A was only .28.

What Was the Relative Degree of Influence of the Four Factors, Training, Experience, Enrollment, and Building Score?

A clearer picture of the relative degree of influence of each of the four factors is obtained by a consideration of the effect upon the excess achievement score of 2.01 for Group A when the two groups were equated on training, then on experience, then on enrollment, and finally on the building and grounds score.

The ordinary method of seeking this information would be through the partial correlation technique. This method has not been here used, partly because of the recent severe criticisms of partial correlation techniques, and mainly because this type of investigation, from its very nature, does not yield extensive enough data to permit safe employment of such technique.

When the two groups were equated on training, then on experience, then on enrollment, and then on building and grounds score, one at a time and in the order named, the Group A excess achievement score of 2.01 shifted first to 2.35 on training, then to 1.16 on experience, then to 1.24 on enrollment, and then to 1.73 on the building and grounds score. The group A excess of 2.01 was changed by a positive .34, a negative .85, a negative .77, and a negative .28 in the order named. This does not show experience more or less important than training or any of the other factors. The data here assembled were necessarily too limited to permit treatment by those statistical methods which would permit conclusions concerning the relative individual influence of these factors.

Each of these four factors, according to the evidence at hand, seems to play its own part and to be directly associated with returns. Each has been shown to be correlative with the amount of the expenditures. Each has now been shown also to be correlative with returns. Each is obtainable and largely possible in higher degree only with higher expenditures. Each, when existent in higher degree, brings higher returns. It seems that through the avenue of these four factors, higher expenditures make higher returns not only possible but probable.

CHAPTER XIII

TRAINING, EXPERIENCE, AND ENROLLMENT

To What Extent Did Higher Teacher Training, Longer Teaching Experience, and Larger Pupil Enrollment Jointly Account for the Achievement Superiority of the Higher-Expenditure Schools?

THE case has been examined with the two groups of schools (1) on a par as to teacher training, Group A averaging higher in all other factors measured; (2) on a par as to teacher experience, Group A averaging higher in all other measured factors except teacher training; (3) on a par as to pupil enrollment; and (4) on a par as to building and grounds score.

From the evidence at hand, training, experience, and enrollment seem to be most highly correlated with the superiority of the higher-expenditure schools. They seem to most affect the returns in the form of pupil achievement, general school happiness, etc.

The building and grounds score has some direct relationship to returns, and there may, of course, be many other unmeasured factors partly conducive to higher returns.

To build a single index from any combination of influencing factors, the most logical step is to start with those factors which singly are believed or known to be highly correlated with high returns. If this is done, teacher training, teacher experience, and pupil enrollment must be included. See Table XV, page 47.

For a consideration of the relation between expenditures and educational returns when the groups were equated on training, experience, and enrollment combined, it is necessary to repeat certain relevant facts: With conditions operating as they were at the time of the tests, Group A averaged lower in training, higher in experience, and higher in enrollment; under these influencing conditions, Group A had an achievement score excess of 2.01. When Groups A and B were equated on training, Group A, higher in experience and enrollment, had an excess achievement score of 2.35. The new evidence now lies in this fact: Equating the two

TABLE XIII

GROUPS A AND B EQUATED ON TEACHER TRAINING, EXPERIENCE, AND
ENROLLMENT

GROUP	NO. OF CASES	MEAN EXPERIENCE	MEAN TRAINING	MEAN EN-ROLL-MENT	MEAN BLDG. SCORE	MEAN SALARY	MEAN PUPIL WTD. EX-PENDI-TURE
A.........	103	7.3 yrs.	1.8 yrs.	18	313	$1,223	$1,587
B.........	110	7.28	1.8	18	260	1,120	1,351

TABLE XIV

ACHIEVEMENT OF GROUPS A AND B WHEN EQUATED ON TRAINING,
EXPERIENCE, AND PUPIL ENROLLMENT

GROUP	MEAN ACHIEVE-MENT	S.D.	S.D. M	DIFF.	S.D. diff.	E.C.	CHANCES OF RELI-ABILITY	EQUATED DIFF.
A............	27.35	10.20	1.00	0.35	1.44	.08	7 to 5	.06 yr.
B............	27.00	10.91	1.04					

groups on all three factors at once, training and experience and
enrollment, greatly reduced the excess in achievement for Group
A—from 2.35 to 0.35. In other words, 200/235 or 85 per cent of
the largest found excess vanished with Group A's advantages in
training, experience, and enrollment; really the advantage lay in
the last two factors, experience and enrollment, inasmuch as the
groups were about equal in training. See Tables XIII and XIV.

The new difference of 0.35 is but 15 per cent of the former differ-
ence; the equated difference, then, was but .06 of one year. Its
reliability is very low; there are only 7 chances to 5 that it is at all
reliable.

In the equating of the two groups on the three influencing fac-
tors, training, experience, and enrollment, more exactly what did
actually happen was: first, an increase from 2.01 to 2.35 in the ex-
cess for Group A when the groups were equated on training, in
which Group A was lower than Group B; next, a decrease in the
excess from 2.35 to 0.35, when the groups were equated on experi-
ence and enrollment, in both of which factors Group A had
originally been higher.

TABLE XV

GROUPS A AND B COMPARED AS CONDITIONS WERE FOUND

GROUP	MEAN TRAINING	MEAN EXPERIENCE	MEAN ENROLLMENT	MEAN BLDG. SCORE	MEAN ACHIEVEMENT
A.............	1.39 yrs.	11.4 yrs.	23	313	28.73
B.............	1.77	6.6	16	233	26.72
Diff..........	− .38	4.8	7	80	2.01

TABLE XVI

GROUP ACHIEVEMENT MEANS

GROUP	NOT EQUATED	EQUATED ON				
		Training	Experience	Enrollment	Training, Experience, and Enrollment	Bldg. Score
A.........	28.73	29.07	28.37	28.68	27.35	29.02
B.........	26.72	26.72	27.21	27.44	27.00	27.29
Diff.......	2.01	2.35	1.16	1.24	.35	1.73

The remaining excess of 0.35 in the achievement score for Group A, when the two groups were equated on training, experience, and enrollment, being but 35/235 or 15 per cent of the greatest difference found between these two groups or the difference found when Group A was equal to Group B in training, and higher than Group B in the other two factors, experience and enrollment, indicates that not more than 15 per cent of the obtained excess achievement for Group A, was due to influencing factors other than training, experience, and enrollment, and other variables closely associated with these three. This is shown in Table XVI.

Whether teacher training, teaching experience, and pupil enrollment are accepted as directly causal or not, is not the whole of the question. This much is true: in so far as they are not causal, these three factors are directly associated with whatever may be the more immediate causes of the difference in pupil achievement between Group A and Group B.

The conclusion, then, is that the amount of training and experi-

ence of the teacher, and the number of pupils enrolled are three factors which are causal or are directly associated with pupil achievement. Furthermore, a combined measure of teacher training, teaching experience, and pupil enrollment may be expected to give a fairly good index of approximately 85 per cent of the difference between average pupil achievement in different schools.

Was the Remaining 15 Per Cent of the Superiority of the Higher-Expenditure Schools Correlative with Higher Teacher Salaries? Higher Scoring Buildings and Grounds?

Group A when equated with Group B on training, experience and enrollment was still superior in pupil achievement, as is indicated by the remaining achievement score excess of .35; when so equated, Group A also averaged slightly higher in teacher salary. This Group A salary excess may possibly be correlative with a certain greater degree of intelligent interest or with other desirable qualities of the teachers. The higher salaries may make such superior qualities in teachers more readily obtainable.

When equated on these three factors, Group A was also a bit higher in the building and grounds score. This higher score of the buildings and grounds may possibly indicate a certain higher level of intelligent interest, responsibility, and coöperation in the members of the community who maintain the school.

In other words, there is a possibility, though the evidence is insufficient to assure certainty, that this remaining achievement difference of .35 or approximately 15 per cent of the whole of Group A's achievement excess, may be correlative with the smaller difference remaining in teacher salaries and in the scores on buildings and grounds.

CHAPTER XIV

POSSIBLE CRITICISMS OF THIS STUDY

1. The basic underlying assumption of genuine randomness of sampling has been largely disregarded in presenting and interpreting the measures of reliability. The total distribution of schools was split into groups no one of which was then a normal distribution. The reliability measures therefore only approximate the facts. The nature of the sampling does necessarily limit the validity of such measures as well as the conclusions drawn from the investigational findings.

Nevertheless the reader should be aware that the sampling of measured schools was so made as to be quite representative of the state as a whole.

2. The partial correlation technique ordinarily accepted for such analyses has not been used. To determine intrinsic connection between causal factors and returns, other and probably more crude methods have been employed. It appears from recent criticisms that the partial correlation technique as a device for analyzing interrelationships may in itself be somewhat faulty. The main interest in this study lay more with determining the general direction rather than the absolute amount of the influence. To use such a highly refined technique in the analysis of data so limited as to be inadequate for such analyzing methods would have been an indefensible procedure. The nature and limits of the data here assembled would not warrant the use of the partial correlation technique.

3. It is admitted that there may have been certain unmeasured causal factors such as, for example, community influences. Conclusions drawn from incomplete evidence are, to that extent, without value. In so far as was feasible, all such factors have been considered and equated group for group. Furthermore, by far the largest amount of intergroup differences in returns have been accounted for by influences actually measured.

4. There may have been some inadequacy in the measurement

of returns. Not every part of the gross total educational changes in the child was measured; not all children were measured.

The facts, notwithstanding, are that many different traits have been measured and that in education good things tend to go pretty much together. These measured traits showing one group so consistently superior to the other group of schools do most likely give a fair index of the true picture.

5. There may have been some inaccuracy of measures. Probably nothing has been measured with one hundred per cent accuracy. The tests were probably fairly reliable; and for comparison of groups, which was the main interest in this study, approximate accuracy of measures was all that was needed. The measures were the same group for group, and comparisons were quite fairly made.

6. The upper limit of the amount of expenditures beyond which there may be diminishing returns has not been discovered. Data of the kind and amount necessary for answering this question were not obtained.

7. To determine the relation between any two traits, between teacher training, say, and pupil achievement, a redivision of all measures on the basis of one of these traits, say, teacher training, could have been made. The average pupil achievement scores in the upper and the lower teacher training halves could then have been compared. This method would probably give a truer picture of the amount of relation between returns and the various factors. It was not deemed necessary to show the exact relationship but merely to show that there was a significant relationship. The method employed served this purpose.

8. Does this study mean that spending more money will automatically bring higher returns in any particular school? It does make it highly probable that giving each school more money will enable it to secure greater returns. There may be some grounds for the fear that merely giving every school more money would leave each individual school in its same present relative position and leave the lower-expenditure schools still unable to compete.

It is impossible to foresee; and, if foreseen, to remove entirely the causes for every just criticism. A reasonable effort has been made to discover the important facts, to limit the conclusions to those fairly drawn from the evidence at hand, and to make recommendations accordingly.

CHAPTER XV

SUMMARY, CONCLUSIONS, AND RECOMMENDATIONS

The Problem

THE main purpose of this investigation was to discover the relation between current school expenditures and educational outcomes in one-teacher schools.

Method of Attack and Sources of Data

The equivalent-groups method of investigation was used. The data on current expenditures of the 7,059 one-teacher schools of New York State were obtained from the records in the Department of Education at Albany. For intensive and detailed investigation, one county was selected as typical of the state as a whole. For comparison as to relative educational returns, the schools of this county were divided into two main groups. Group A was made up of schools from the higher-expenditure half and Group B from the lower-expenditure half of the one-teacher schools of the state. The groups were equated in supervision and "outside of school" influences in general. Pupils were measured in certain traits, and other data were secured in each school, by first-hand investigation.

The Findings

The approximate median of current expenditures for one-teacher schools in the state of New York was $1,500. For this investigation two groups of schools were selected as above-median and below-median in expenditures. Group A expenditures averaged $1,746 and Group B expenditures averaged $1,337.

All 10-, 11-, 12-, 13-, and 14-year-old children were measured in achievement in nine different traits: reading accuracy, spelling, reading comprehension, language usage, health knowledge, history and civics, geography, elementary science, and arithmetic. From a combination of the scores in these measures, a total achievement score was derived. Measures were also made in general school happiness.

The pupils of Group A were superior in every measure made.
They were most superior in history and civics and least so in
language usage. In total achievement, the Group B pupils were
found to be retarded by .37 of one year in five.

The reliability of the obtained superiority of the higher-expendi-
ture school pupils was indicated by the experimental coefficient of
the difference as 15 chances to 1.

These two main groups were subdivided, forming Subgroups 1,
2, 3, and 4, having average expenditures of $2,130, $1,594, $1,402,
and $1,204 and average achievement scores of 30.54, 28.16, 27.71,
and 23.70 in the order named.

*The pupils in the lowest-expenditure group of schools were found
to be retarded by 1.44 years in five, when compared to the pupils of the
highest-expenditure group of schools.* This means that it would
take the pupils of the lowest-expenditure group of schools 1.44
years more, at their rate of improvement, to make sufficient gains
to bring them up to the level held by the pupils in the highest-
expenditure group of schools at the time of the tests. There is
more than practical certainty as to the reliability of this obtained
superiority.

These reported differences are due to factors other than a differ-
ence in relative mental ability, on which all pupils were measured
and the different groups were equated.

The pupils of the second lowest-expenditure group of schools
were retarded by .51 of one year in five; the pupils of the third
lowest-expenditure group of schools by .42 of one year in five.

There were found to be about 14 chances to 1 that the pupils in
the Group A or above-median-expenditure schools, were happier
students than were the pupils of the Group B schools.

*To sum up, expenditures and returns in form of pupil achievement
were found in this investigation to rise and fall together.* Consider-
ing the number of pupils enrolled in the school, the average
achievement of each pupil and the current expenditure cost to the
district, *the dollar-for-dollar returns in the lowest-expenditure sub-
group of schools were but 59 cents on the dollar* as compared with the
returns of the highest-expenditure schools. In the lowest-ex-
penditure group of schools, the enrollments were smallest, the
achievement was lowest, and the per-pupil costs were highest of
all the schools studied.

Higher expenditures are not, of course, directly causal. They

merely purchased such causal factors as higher teacher training, longer teaching experience, larger pupil enrollment, and better school buildings. Each of these factors was found correlative with the superiority of the higher expenditure schools. That is to say: (1) *A higher level of average teacher training is directly associated with a correspondingly higher level of average pupil achievement.* (2) *A higher level of average teaching experience of the teachers employed is directly associated with a correspondingly higher level of average pupil achievement.* (3) *Larger pupil enrollment is directly associated with a correspondingly higher level of average pupil achievement.*

The amounts of training and experience of the teacher and the number of pupils enrolled combined into one measure may be expected to give a fairly good index of approximately 85 per cent of the difference between average pupil achievement in different schools.

The remaining 15 per cent of the superiority of the higher-expenditure schools is probably correlative with certain other superior qualifications of the teacher and with better school plant.

Recommendations

1. In practically all the one-teacher schools of the state, higher expenditures per school must be made possible if greater educational returns are to be secured.

2. In most of the school districts, the increased expenditures per school should be made possible by widening bounds, thus enlarging the total taxable wealth per school unit, rather than by any increase in taxes.

3. The present economic waste and educational failure in the small schools of the state—and especially in the 21 schools enrolling but one pupil—should be eliminated by increasing of enrollments through this widening of district bounds. It would be an excellent thing to have such a teacher as "Mark Hopkins" on his "log," but he should certainly take good care of more than one "pupil." Probably as many as 30 pupils to the school would make higher educational returns more possible.

4. Transportation should be provided for the more remote pupils in the enlarged districts. The added cost of all necessary transportation is a small item when compared with the cost of maintaining another school.

5. The present low standard of teacher training should be raised. Higher per-school expenditures should be so utilized as to secure better trained teachers.

6. Expenditures should be so utilized as to continue the present practice of retaining the services of experienced teachers. Naturally superior teachers, and well-trained teachers improve with experience.

7. In most cases buildings and equipment should be improved and school grounds greatly enlarged.

8. In short, the thrifty taxpayer should look to the size of the enrollment in the school, to the adequacy of the building and grounds, equipment, supplies, and most of all to the worth of the teacher. In the teacher, the amount of training, the length of previous teaching experience, and proven ability especially in successfully directing fairly large schools are three factors which may be depended upon as indicative of superior teaching power.